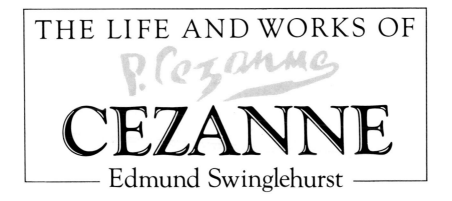

THE LIFE AND WORKS OF

P. Cezanne

CEZANNE

Edmund Swinglehurst

A Compilation of Works from the

BRIDGEMAN ART LIBRARY

SHOOTING STAR PRESS

Shooting Star Press Inc
230 Fifth Avenue, New York, New York 10001

Cézanne

This edition first published in Great Britain in 1994
by Parragon Book Service Limited

© 1994 Parragon Book Service Limited

ISBN 1 85813 511 7

Printed in Italy

Designer: Robert Mathias

PAUL CÉZANNE 1839-1906

ONE OF THE IRONIES of the history of art is that its course should have been changed so dramatically by a man who at first had a relatively limited natural facility for drawing and painting and a rather introspective nature. In his personal struggle to create an art which would satisfy his own feelings about nature and his stubborn refusal to be deflected from his purpose, Cézanne broke the established format of painting techniques and opened up new avenues to be explored by those who came after him.

Very early in his career Cézanne decided that Impressionism was far too ephemeral for him. What he wanted was to paint, not the transitory effect of surface reflections, but the eternal truths about the forms of nature. This truth, he felt – and in this his thinking was in line with the scientific ideas of his time – lay in the structure of matter itself. In order to establish this he studied the way light described solid objects through the planes of their shapes which were all forms of the cylinder, cone and sphere. These were, he decided, the three fundamental shapes of all things; the fundamental colours were the primary and secondary colours with which the Impressionists had experimented.

Armed with these basic principles, Cézanne began to construct his view of nature, moving from the dark colours and heavy impasto of his early work into a new kind of interpretation of the visible world which would create a

new vision of art.

Paul Cézanne was born in Aix-en-Provence on 19 January 1839. His father was a businessman who owned a hat factory and would soon have a partnership in a private bank. After some success at drawing at school, where his best friend was Emile Zola, later to become as famous a writer as he was a painter, and a time at law school in Aix, Cézanne persuaded his father to let him study art. In Paris in 1861 he joined the Académie Suisse, where he met Camille Pissarro, but was rejected by the Ecole des Beaux Arts. He returned, disappointed, to Aix and joined his father's bank. Cézanne soon tired of this, returned to Paris in late 1862 and rejoined the Académie Suisse where he now met Renoir, who became a close friend, and Monet, Sisley and Bazille.

From now on Cézanne pursued art with a single-minded purpose. He divided his time between Paris and Aix, though when the Franco-Prussian war broke out in 1870, Cézanne fled to L'Estaque on the Bay of Marseille with his model and mistress Hortense Fiquet. He avoided going to Aix because he was afraid of his father's displeasure at this liaison. Hortense gave birth to Cézanne's son, Paul, in 1872, but was not married to him until 1886, Cézanne's austere father having at last acknowledged their relationship. In the quiet of L'Estaque Cézanne began consolidating the ideas about painting that he had picked up in Paris, though it would be some time before any but his friends took his work seriously; to most critics, and to the public, he was an inept madman.

In 1889, at the age of 50, he finally had a painting accepted by the Salon in Paris and began to exhibit a little more regularly. His first one-man show did not take place until 1895, at the Vollard Gallery; even now he was not

accepted by most critics or the public. Opinions were changing, however, and many of the Impressionists, such as Monet and Renoir, were making a good living out of painting. Cézanne's success was not to come until after his death. In 1906, the year he died, ten of his works were exhibited in the Salon d'Automne and in the following year, 56. Thereafter, Cézanne's fame continued to increase and on the centenary of his birth there were major exhibitions of his work in Paris, London, Lyon and New York. Today, on the rare occasion a painting by Paul Cézanne is sold at auction, it is likely to fetch an enormous sum, beyond the wildest imaginings of Cézanne and his contemporaries.

▷ **Achille Emperaire** c.1867

Oil on canvas

ACHILLE EMPERAIRE, a misshapen dwarf, was a life-long friend of Cézanne and a fellow painter. This large portrait is an early work, when Cézanne painted with heavy impasto and somewhat clumsily, compared to the delicacy of his later work. There was a baroque quality about his early work, evident in his figure compositions and, more unusually, in this portrait. Another portrait of Achille Emperaire of this period was rejected by the Salon in 1870. Victor Gasquet described the Salon painting as 'of a man, hungry for life, a creature of caricature, limp hands and fine sad face turned aside, overhead his name rather wryly proclaimed Achille Emperaire.'

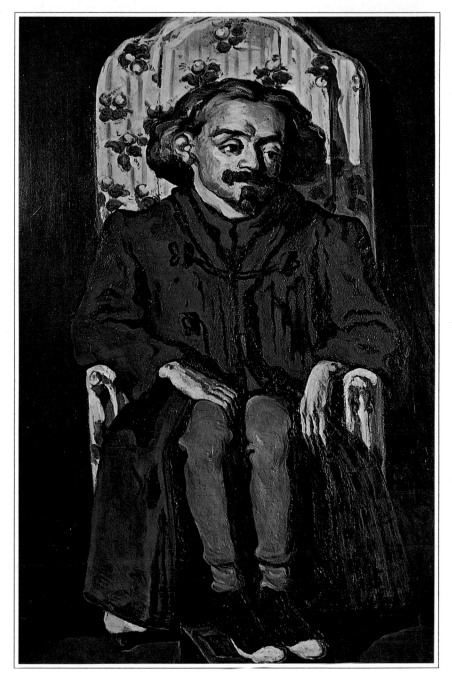

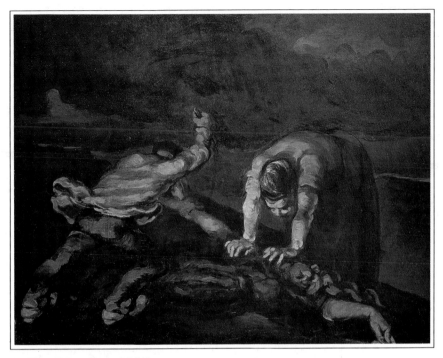

△ **The Murder** 1867

Oil on canvas

ALTHOUGH CÉZANNE became a disciplined painter with a classical style, there was a wilder, romantic side to him which showed itself both in the young artist and, though more controlled, in the older one too. *The Murder* and *A Modern Olympia* were early examples of Cézanne's romantic streak, while the bather studies of the older artist showed that the feeling was still strong. It was this inner passion for life which gave a fierce strength to even the most clinical dissections of nature in his later paintings. In *The Murder*, the artist was giving way to a direct response to horror rather in the manner of the Expressionist painters; later, he learned that a disciplined passion could be even more effective in artistic terms.

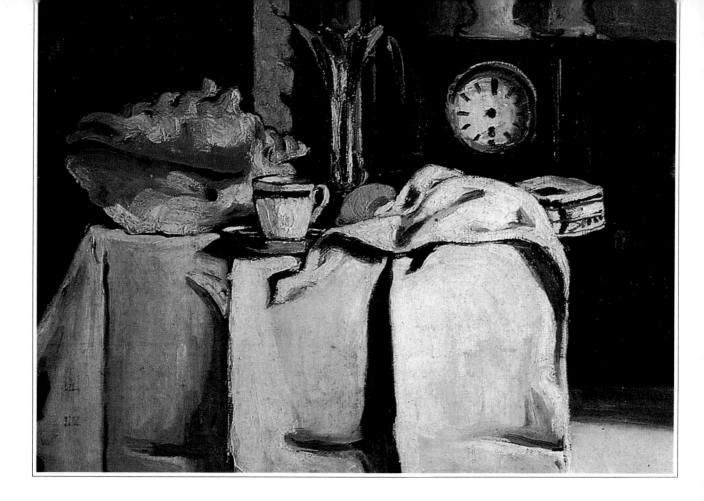

△ **The Black Marble Clock** c.1869-70

Oil on canvas

DESPITE ITS RELATIVELY small size this still life of a black marble clock has a monumental quality about it that foreshadows Cézanne's later work. In the picture, too, are elements which were to become familiar items in a Cézanne still life: there is the folded cloth, a basket with fruit, a vase and a teacup. In his pursuit of the nature of solid objects Cézanne at first laid on his paint heavily, in the old master style apparent in this picture; it was towards the end of his life that he came to the conclusion that solidity could just as well be described by subtle layers of paint.

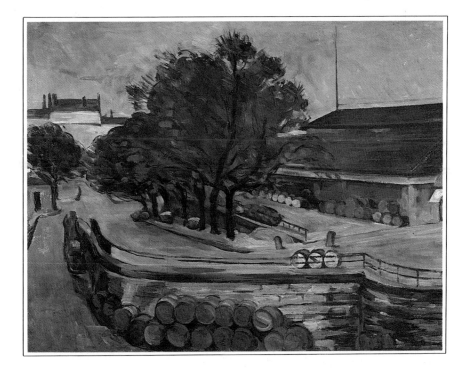

△ **The Halle aux Vins** 1872

Oil on canvas

PARIS IN CÉZANNE'S DAY was famous for its many markets, among which was the Halle aux Vins, where wines were brought from all regions of France. This painting of a scene close to the hearts of the Paris bourgeoisie shows the young Cézanne painting with thick impasto in the style popular with the established art world of the day. It was a style which reflected the sombre, solid work of the post-Napoleonic French middle class, with their heavily furnished homes and pompous style of dress.

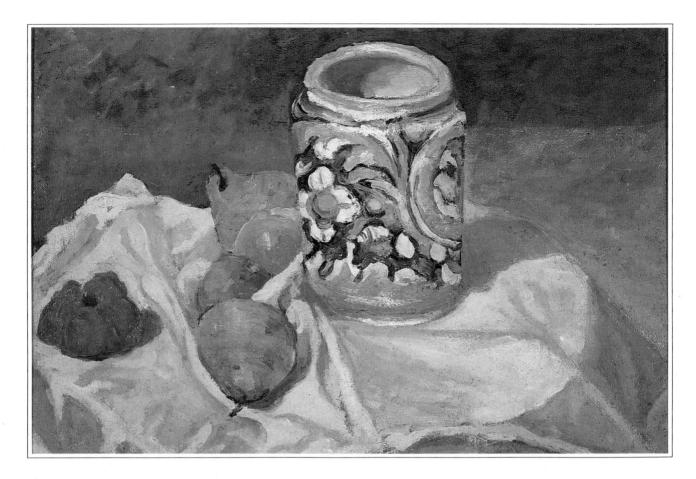

△ **La Faience Italienne (Italian Ceramic Pot)** c.1873

Oil on canvas

THERE IS A GREAT FRESHNESS and charm about this early Cézanne still life and the jolly ceramic pot reveals the painter's life-long love of the objects and fruits which were an essential part of everyday life. Unlike painters who sought inspiration and new ideas in foreign places and climates, Cézanne was a stay-at-home character – apart from one trip to Switzerland – who found all the stimulus he needed in his own studio or in places that he had come to know well. The source of his creativity, like that of all original artists, was in his own mind.

▷ **Self-portrait with Casquette** 1873

Oil on canvas

HATS, OR HEADGEAR of all kinds, have always played an important part in portraits: think of Rembrandt and his helmets, turbans, flowered hats and so much else, or of all those 'Renoir girls' and their wonderfully fashionable concoctions. Cézanne was not much given to dramatic gesture, so it is perhaps a little surprising to encounter him in this self-portrait wearing a quite exotic piece of headgear. He appears amused, however, and there is indeed a touch of humour about this heavily bearded man with his little black cap looking like a character out of Dostoievsky.

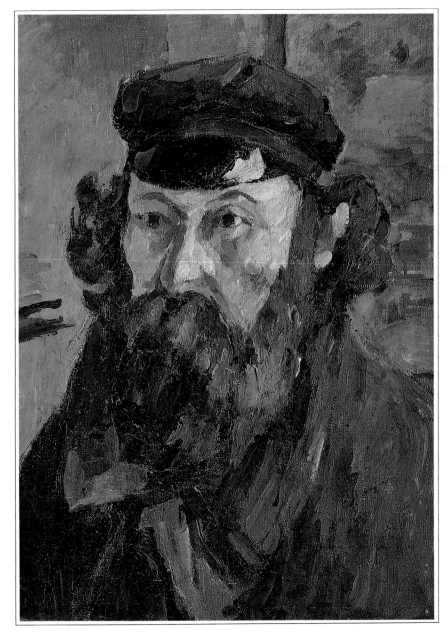

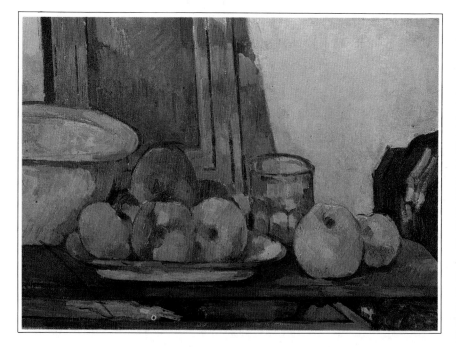

△ Still Life with Open Drawer 1873

Oil on canvas

THIS STILL LIFE dates from a period in Cézanne's life which was fruitful both personally and artistically. His son Paul was born in 1872 and soon after the birth, the family settled in Pontoise. Cézanne was also widening his circle of friends and contacts in the French art world. At Auvers-sur-Oise he had become friendly with Dr Gachet whose friendship and support was to mean so much to other young artists of the day, most notably Vincent van Gogh. At Auvers Cézanne had also renewed his acquaintance with Camille Pissarro, doyen of the new generation of artists who were challenging the artistic establishment of Paris.

▷ The House of Dr Gachet c.1873

Oil on canvas

DR GACHET, who lived at Auvers-sur-Oise, north of Paris, was an art-lover, homeopathic doctor and friend of many of the revolutionary painters branded as Impressionists (including van Gogh, whom Dr Gachet tended in his last months). Gachet's house in Auvers became a congenial meeting-place for the artists, their discussions being a source of new ideas. Cézanne was drawn into the group by his friend Camille Pissarro and found the free-and-easy atmosphere much to his liking. Among the many paintings he did at Auvers were several of the road through the town to Dr Gachet's house. This one is among the finest of them. Its composition is centred on the tree growing by the Gachet house and is balanced by the converging diagonals of the road, which Cézanne has deliberately painted rising up the picture.

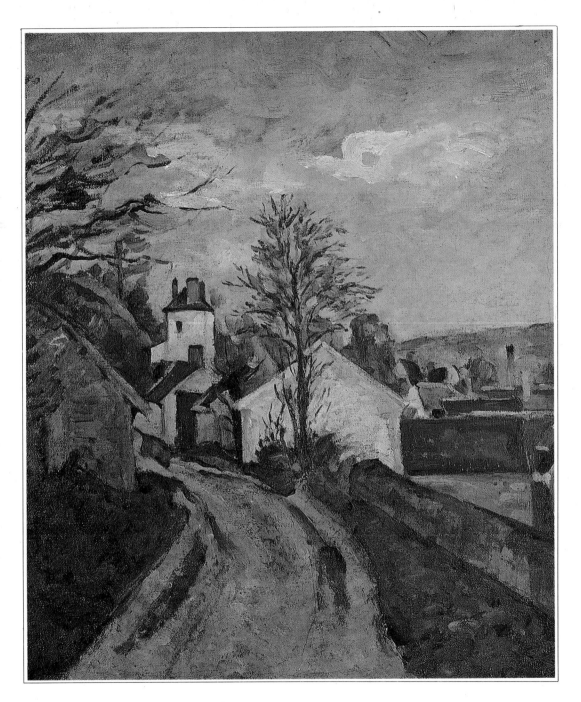

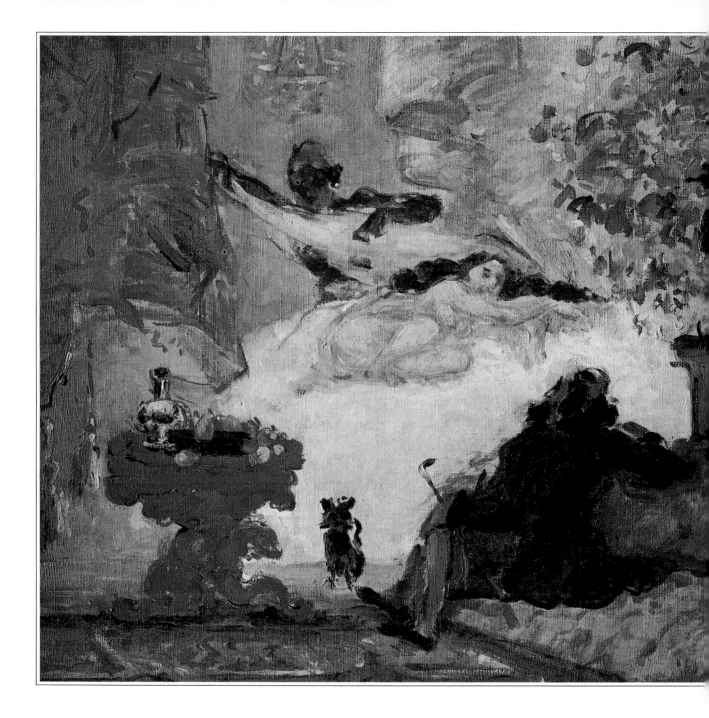

◁ **A Modern Olympia** c.1873

Oil on canvas

IN CONTRAST WITH his disciplined and austere maturity, the young Cézanne appears as a romantic painter with a taste for the baroque. This may have been the result of his literary leanings, encouraged by his friendship with Emile Zola, and of his only youthful source of contact with painting, the Provençal artists. The *Modern Olympia* also has a flavour of Delacroix, to whose work Cézanne had been introduced by Zola at the Salon des Refusés. Cezanne sent *A Modern Olympia* to the first Impressionist Exhibition in 1874, where it was derided by a critic, Marc de Montifaud, who wrote, 'M. Cézanne appears to be a kind of madman, stirred up while painting into a *delirium tremens'.* Cézanne had given his painting the same name as Manet's famous painting which had caused such a stir at the 1865 Salon, perhaps in homage to Manet's work, which Cézanne admired. The painting was bought by Dr Gachet who looked after (and was painted by) van Gogh in the last months of his life.

▷ **The House of the Hanged Man** 1873-4

Oil on canvas

THIS PAINTING was one of three works exhibited by Cézanne at the first Impressionist Exhibition in Paris in 1874. It is one of the most accomplished of Cézanne's Impressionist paintings and has more than a passing resemblance to the work of Camille Pissarro, whom he met in the early 1860s and who had advised him to give up browns and earth colours and to paint with primary colours and complementaries.

From this time on, Cézanne began to observe nature closely and to become sensitive to the effects of light on solid objects. He soon found that he was more interested in defining structure than merely superficial colour effects. The house in this painting is heavily painted because, as he told Maurice Denis, 'I cannot express what I want in one spontaneous stroke so I need to put on more and more paint.'

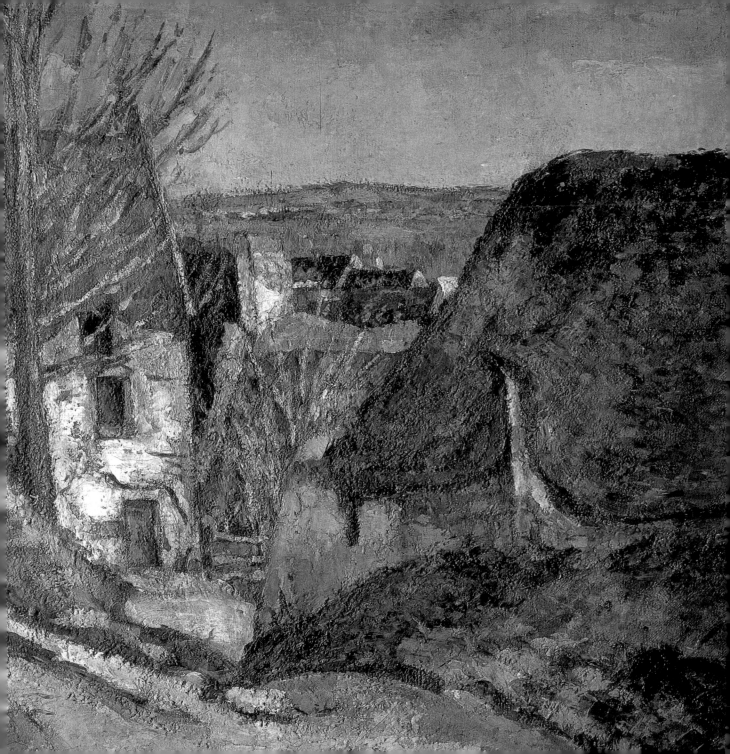

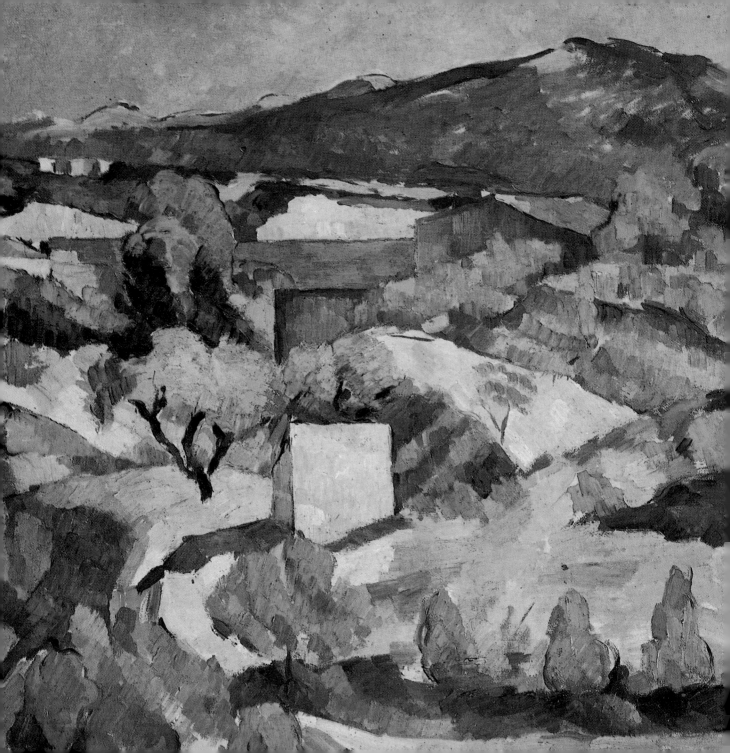

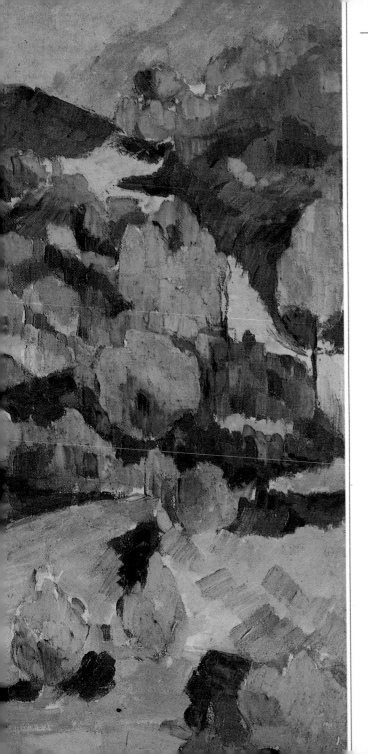

◁ **Mountains of
L'Estaque** c.1876

Oil on canvas

WHILE CÉZANNE was making
one of his many stays at
L'Estaque, Renoir visited him
on his way back from Italy in
1883. Having come to the
conclusion, after seeing the
Italian Renaissance painters,
that his own efforts were
insubstantial and his drawing
poor, Renoir now came up
against Cézanne's firm ideas
on form and the structure of
matter. L'Estaque was a
salutary experience for the two
painters: from now on they
both steadily developed a style
and method that brought
them close to the artistic
achievement they sought, but
which neither thought they
had ever reached.

▷ **Poplars** 1879-82

Oil on canvas

UNLIKE MONET, who often had
20 canvases on the go at the
same time as he endeavoured
to catch the fugitive moment,
Cézanne laboured at this
painting of poplars for days.
Each brushstroke had to be
carefully thought out and
placed in exactly the right spot
so that it would lock into the
total composition of the
picture space. Despite this slow
and methodical procedure,
Cézanne's trees are not static
but seem to move with passing
breezes. Only the composition
is as firm as a grid with its
vertical tree trunks and the
horizontal yellow wall which
provides a focal point as well
as a horizontal anchor.

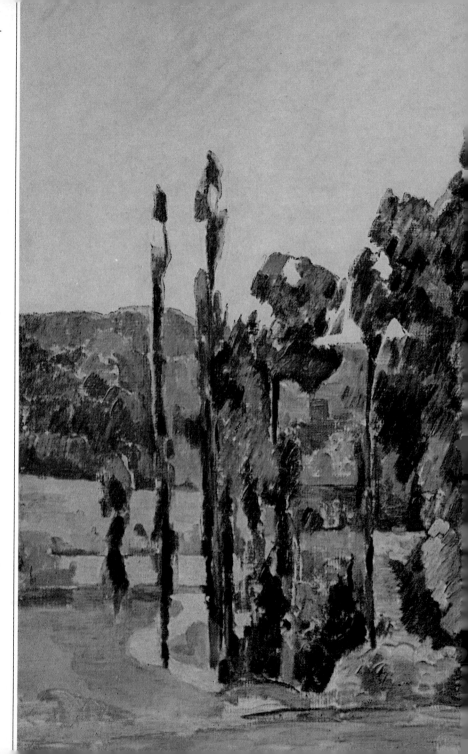

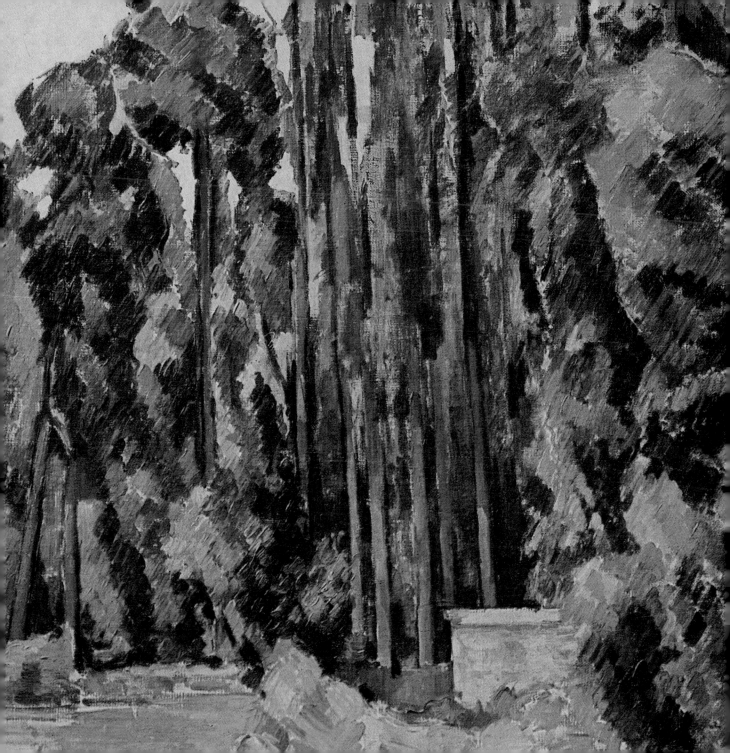

▷ Self-portrait c.1879-80

Oil on canvas

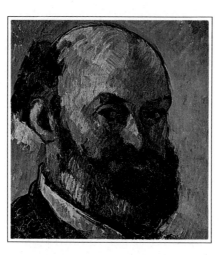

LIKE MOST PAINTERS, Cézanne found that his most convenient and readily available model was himself. Thus there are many Cézanne self-portraits in existence, the earliest dating from the late 1850s and the last from c.1898. Each one is an exercise in some aspect of the artist's search for the way to the perfect painting. They also give us an insight into Cézanne's character. A stubborn, introspective man, quite free of personal vanity and with little time for the fashionable world of art, Cézanne gazes out of his self-portraits in many different moods and guises.

▷ The Bridge at Maincy c.1879

Oil on canvas

MAINCY IS A VILLAGE in a rural area near Melun to the south-east of Paris. Cézanne stayed there from the summer of 1870 to early 1880 and grew to like the green, well-watered countryside, where Impressionists had gathered since their art school days. This painting sees him firmly established in his own style, which André L'Hôte, the cubist painter who later ran a Paris painting studio, called the beginning of Cubism. This painting was sold to Père Tanguy, the artist's colourman and dealer who befriended the Impressionists. It was resold to Victor Choquet, the collector and champion of Impressionism, for 170 francs in 1894.

◁ **Chestnut Trees at the Jas de Bouffan** 1885-7

Oil on canvas

THE JAS DE BOUFFAN (Habitation of the Winds) was a large property near Aix-en-Provence bought by Cézanne's father in 1859 and inherited by the painter. It possessed a splendid avenue of chestnut trees which Cézanne painted many times, at various seasons of the year. In this winter painting Cézanne uses the bare trunks and branches of the chestnuts to make an arabesque of dark shapes through which one can see farm buildings and Mont Sainte-Victoire. Cézanne sold the house in 1900 and moved into Aix-en-Provence. Today, the house belongs to the Vasarely Foundation and houses a collection of the works of the successful op-art artist Victor Vasarely.

▷ **The Banks of
the Marne** c.1888

Oil on canvas

IN 1888 CÉZANNE returned to
Paris after working for a year
at Aix. While in Paris, he often
painted at Chantilly and on
the banks of the Marne, where
he painted several views. He
also met and exchanged ideas
with some of his painter
friends, including van Gogh
and Gauguin, whose work he
did not like. In fact, as his own
work became more mature
and distinctive, he found it
difficult to sympathize with the
aims of his former
Impressionist colleagues,
though he continued to be
friends with Renoir and
Monet.

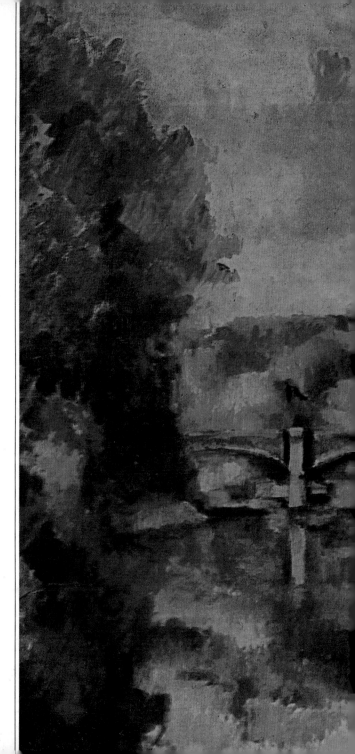

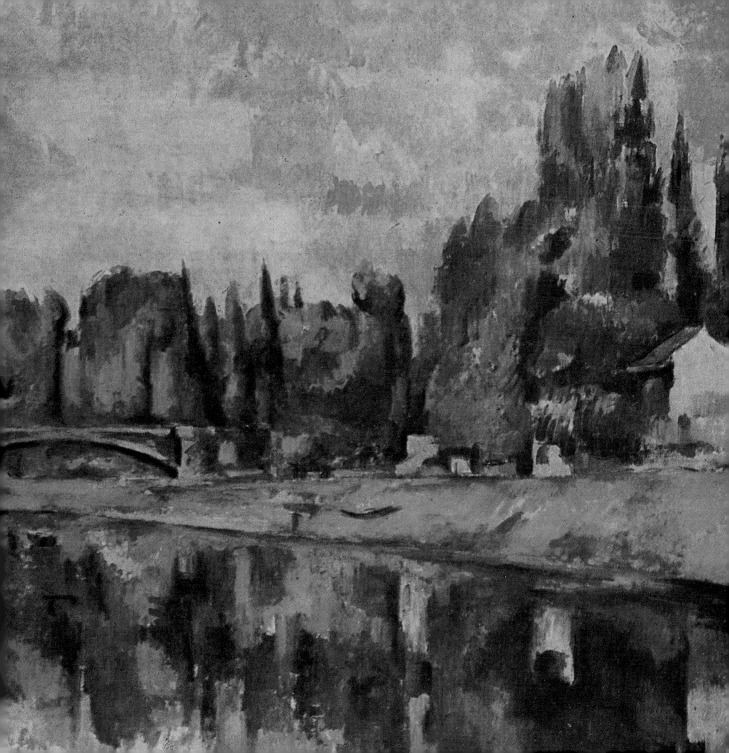

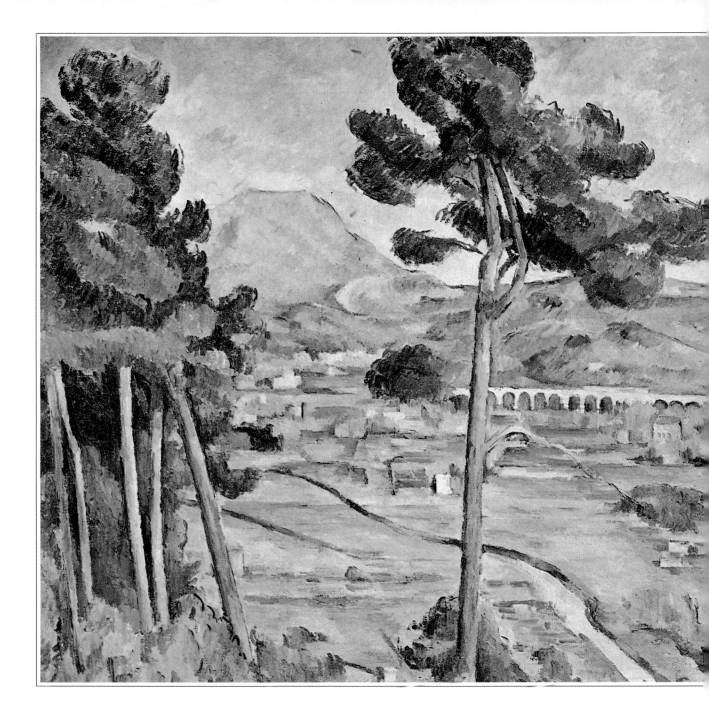

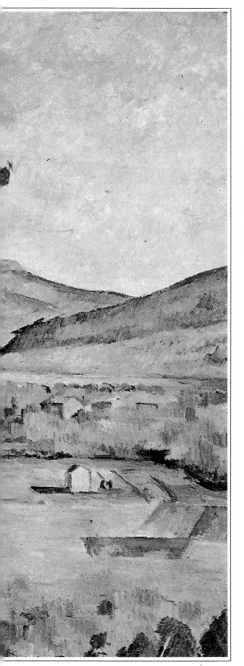

◁ **Mont Sainte-Victoire** c.1886-7

Oil on canvas

THE MOUNTAIN near Aix-en-Provence, named in memory of the victory of the Roman general Marius against the Teutonic tribes, has also become a memorial to Cézanne, who painted it frequently in the last 15 years or so of his life. In this painting he has arrived at a carefully integrated composition of countryside and mountain. He has also managed to incorporate a central pine tree which, without the well-conceived total structure of the painting, might have divided it in two.

▷ **Still Life with Peaches and Apples** 1888

Oil on canvas

CÉZANNE HAS USED a white cloth across the painting to enhance the colour of the fruit in this still life. The jug and the sugarbowl are familiar elements in Cézanne's still lifes, as is the table on which they are all set. Compared to earlier still lifes, such as *La Faience Italienne,* this one seems to be more finely composed, with every element in the picture fully locked into the whole composition.
The artist creates a sense of inevitability which was the key to all his later work.

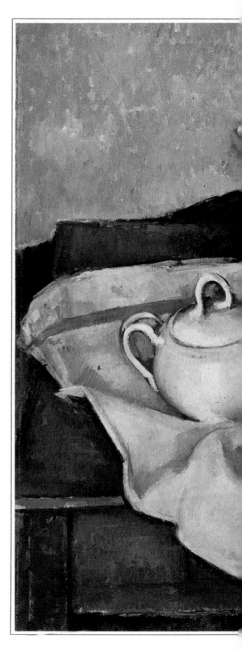

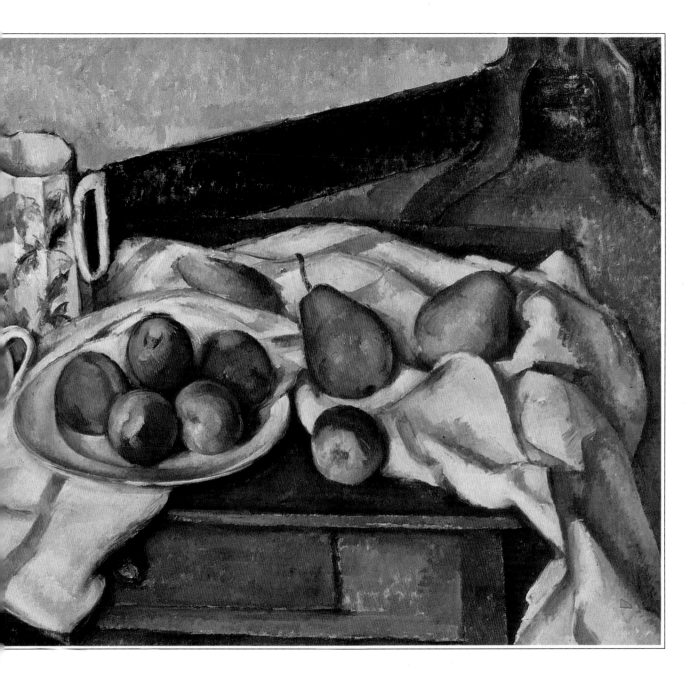

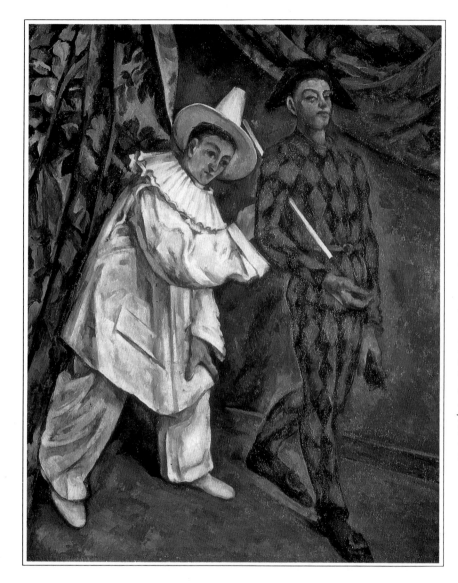

◁ **Mardi Gras (Pierrot and Harlequin)** 1888

Oil on canvas

ALTHOUGH CÉZANNE usually found his inspiration in landscape and still life, there was an exotic side to him which often found expression in his figure compositions. The unusual series of harlequins, painted in the last years of his life, seems to belong to this side of him. *Mardi Gras* is the only one of the series with two figures, posed for by Cézanne's son Paul and their friend, Louis Guillaume. Paul Cézanne also posed for other pictures in the harlequin series. It has been suggested that the usually austere Cézanne was having a bit of a joke, and that the figures represent himself as the harlequin and his ebullient friend Zola as the clown.

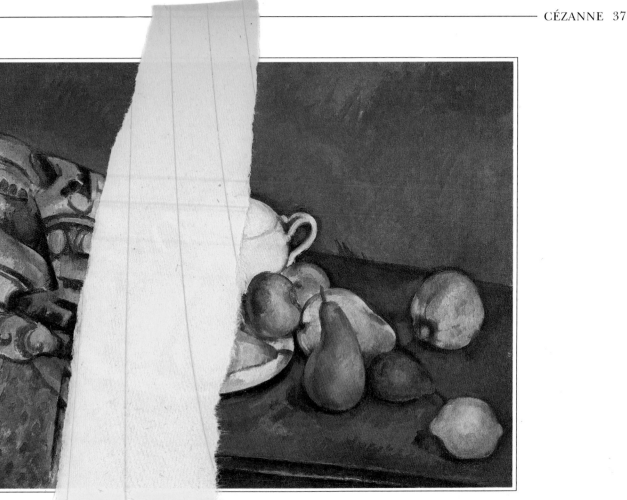

△ **Sucrier,** e with Sugarbowl, Pears and Tapestry) 1888

Oil on can

BY THE L form. His work was by no whose retina is diseased'.
was near ans accepted by all art Today, beautiful still lifes of
birthday ics, however: many were this period in Cézanne's life, of
mature lind to Cézanne's which Sucrier, Poires et Tapis
with a f ements. Thus, J.K. is a particularly fine example,
new av ns could write in 1889 fetch millions of dollars at
relatio anne was 'an artist auction.

▷ **Still Life with Basket** 1888-90

Oil on canvas

WRITING TO EMILE BERNARD in 1905, the year before his death, Cézanne summed up his philosophy of painting, as he had expressed it in countless still lifes and landscapes. 'The main line to follow is just to put down what you see. Never mind your temperament or your ability in respect of nature . . . I am an old man now, nearly seventy, and "colour awareness" from light gives me an awful lot to think about.' This lifetime of thought about light and the material world Cézanne left for posterity in his still lifes, painted in the calm of a studio with plenty of time for thought.

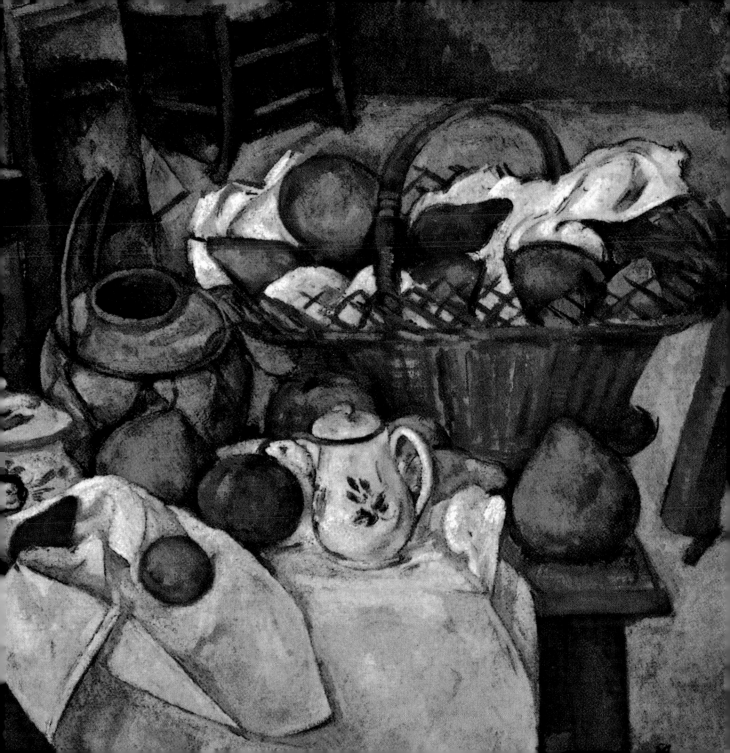

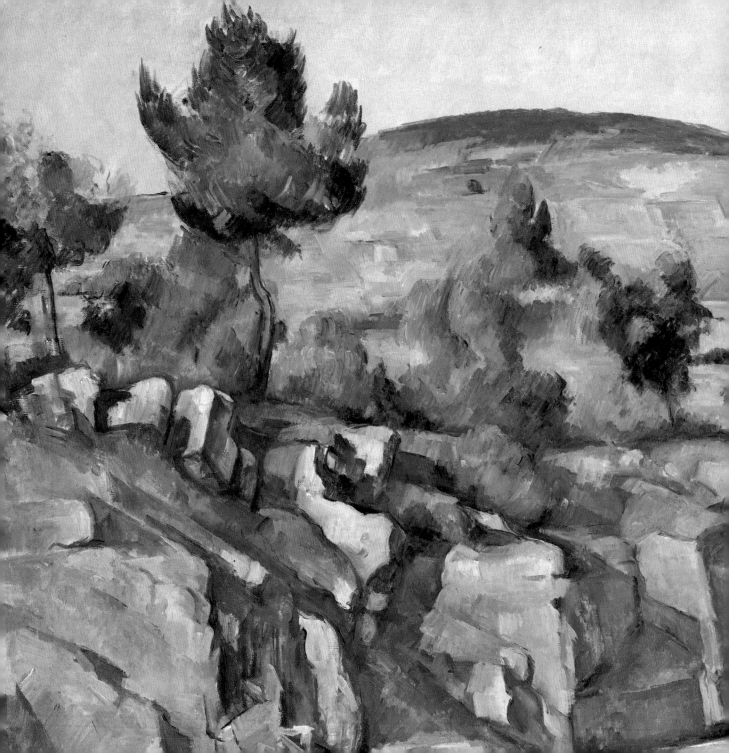

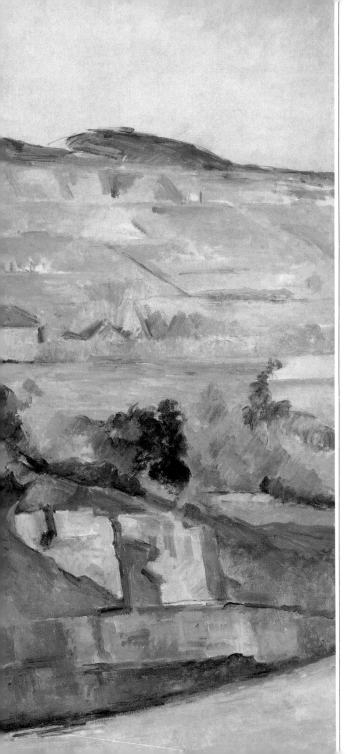

◁ **Mountains in Provence** 1886-90

Oil on canvas

PROVENCE WAS CÉZANNE'S spiritual home, the clear and brilliant sunshine which threw the formations of the landscape into sharp relief, suiting his artistic purpose well. His interpretation of the landscape has imprinted itself on art-lovers to such an extent that today it is difficult not to look at the landscape of Provence other than through his vision of it . In this painting, we see the typical Cézanne view of sharp-edged rocks with deep shadows and highlights bridged by subtle tones. There is also a familiar Provençal farmhouse, its red-tiled roof hidden in the fields that surround it like a rock embedded in the earth.

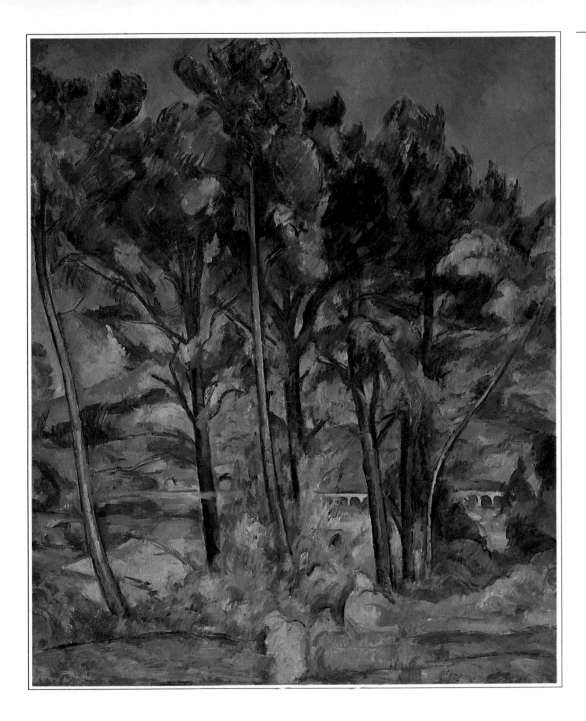

◁ **The Viaduct
(Mont Sainte-Victoire Seen
Through Trees)** 1887-90

Oil on canvas

USUALLY CÉZANNE depicted
Mont Sainte-Victoire without
interposing anything between
it and the spectator, unless
perhaps a tree or two to each
side of the picture. Here, the
mountain and the viaduct –
which is another familiar
feature of the scenery – are
glimpsed through trees. The
trees themselves, painted with
Cézanne's uncompromising
clarity, are the main feature of
the painting, but integrate
beautifully with the
background, making a superb
creative whole.

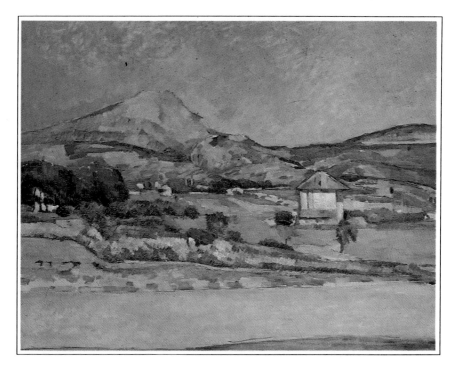

△ **Mont Sainte-Victoire** c.1890

Oil on canvas

IT SEEMS THAT CÉZANNE never
tired of painting the mountain
near Aix-en-Provence that had
first attracted his attention in
1870. Though he did a
painting of it then, his great
obsession began after 1880
when he used to spend hours
in the countryside around Aix,
his native land for which he
felt a fierce love. Mont Saint-
Victoire is actually a ridge
stretching west and east from
Le Tholonet to Pourrières;
Cézanne's favourite view is
from near Gardanne, where
the mountain looks pyramid-
shaped. Cézanne's mountain,
as a result of his paintings, has
become for art-lovers as
famous as Everest has for
climbers.

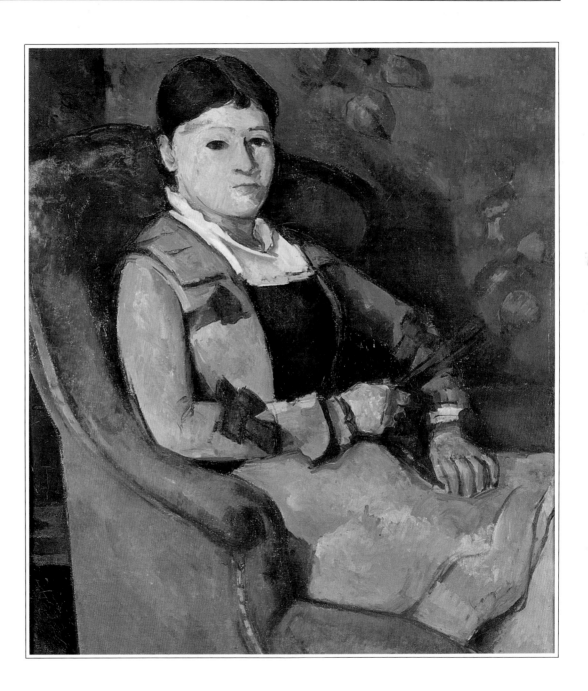

◁ **Madame Cézanne** c.1890

Oil on canvas

HORTENSE FIQUET, Cézanne's model and later his wife, often posed for him, though she no doubt found the long sittings he required rather boring. She was a simple woman who liked a good gossip and got little response from the painter, whose mind was generally filled with the problems of deciding exactly what colour and tone to use on a particular brushstroke and exactly where to place it. In this portrait Cézanne has reached a degree of simplification that foreshadows the paintings of Modigliani who, with the simplest of elements, was able to create portraits of extraordinary reality.

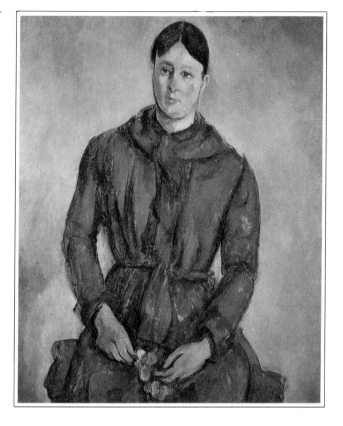

△ **Madame Cézanne in a Red Dress** 1890-4

Oil on canvas

AMONG THE 18 PORTRAITS that Cézanne painted of his wife, Hortense, this is the simplest. She sits against a blank background in a pose with her arms suggesting an oval shape; there is a monumental grandeur about her. The head, which seems small in relation to the body, is another oval and is very plainly painted, compared to the heavily-folded dress. The painting is reminiscent of early Italian artists like Giotto and the Siennese painters, but it is also a forerunner of Modigliani and thus links the past and the present.

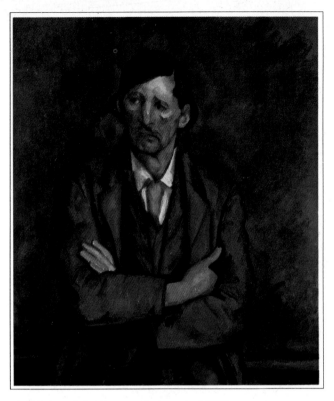

△ **Man with Crossed Arms** 1890

Oil on canvas

CÉZANNE, A SHY and unworldly man, preferred to paint humble, ordinary people – himself, his wife (some 18 times), and the local people who lived near him in Aix. This man looks like one of the group of men who posed for Cézanne's 'card players' series. From his rather smarter appearance – he is wearing a suit – one can guess that he was from a slightly different section of society than the peasants, gardeners and servants Cézanne usually painted. In fact, he was a clockmaker, and therefore a craftsman. Although the artist was not trying to make any sort of social comment in this picture, he has made of the man more of an individual portrait than an undifferentiated representative of a social type.

▷ **Paysan en Blouse Bleue (Peasant in a Blue Smock)** c.1890-5

Oil on canvas

PEOPLE WHO SAT for a portrait by Cézanne had to be patient, their poses simple, for Cézanne expected them to sit for hours, without speaking. This painting was done at a time when Cézanne had lost contact with most of his old artist friends of Paris days, and with his great friend, Emile Zola. In this peasant in his blue smock Cézanne seems to have sensed something of the same *mélancolie de la vie* as in himself. Perhaps to make his point, he has sketched into the background a mural that he painted at his home, the Jas de Bouffan, when he was still close friends with Zola.

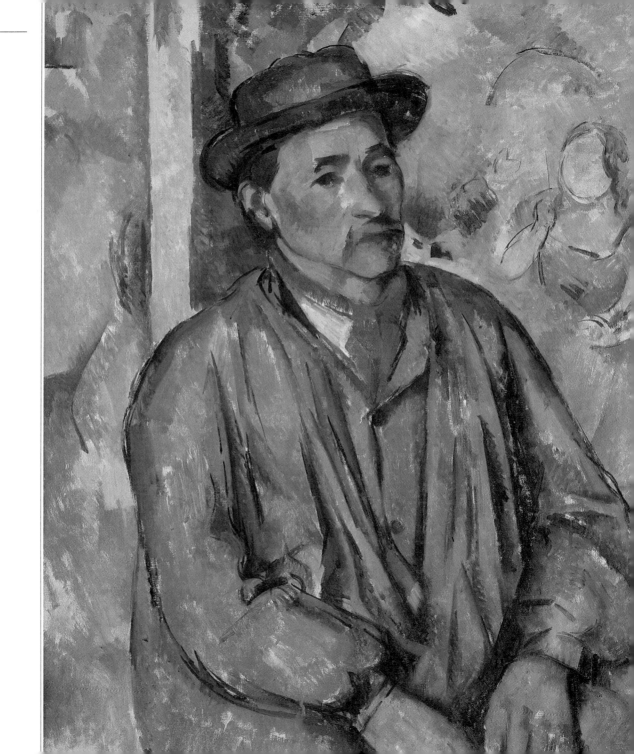

Detail

▷ **Man Smoking a Pipe** c.1890-2

Oil on canvas

THE MAN SMOKING a pipe is Père Alexandre, Cézanne's gardener, who also appears in other paintings, notably *The Card Players* where he is the man with a felt hat on the left. In *Man Smoking a Pipe* he wears the same hat but is facing forwards. The Cézanne saying that 'when colour has its richness form has its fullness' is well exemplified in this painting in brown tones. The figure of Père Alexandre has a splendid solidity, though the paint is applied thinly.

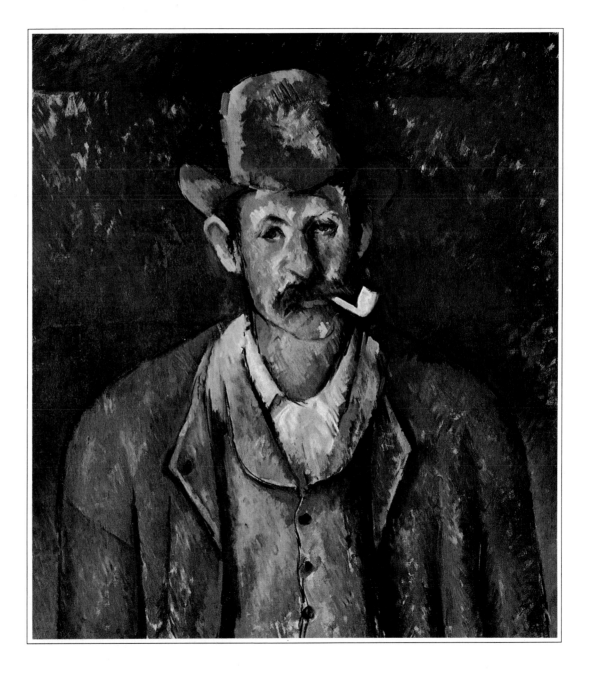

▷ **The Card Players** 1890-2

Oil on canvas

THIS GREAT WORK sums up
Cézanne's mastery of figures
in an enclosed space. Though
the scale of the two figures
seems problematical and
suggests that they were
painted at separate times, a
suggestion enhanced by the
bottle on the table which
divides the painting in two, the
whole comes together wholly
satisfactorily as the planes of
Cézanne's construction weld
the different parts of the
picture together. The potential
drama of two men at a
competitive game is absent
here; what remains is the work
of art, an entity itself and an
original creation.

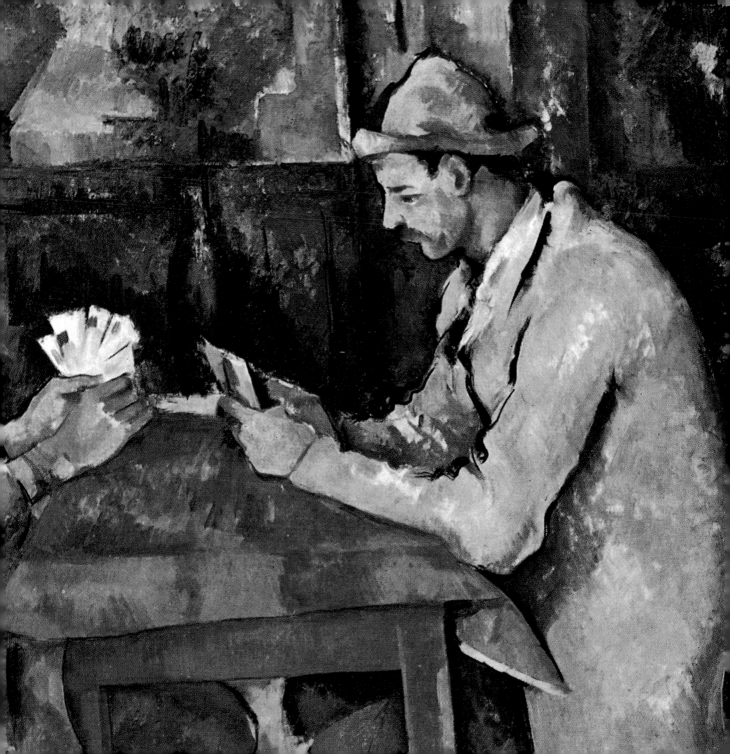

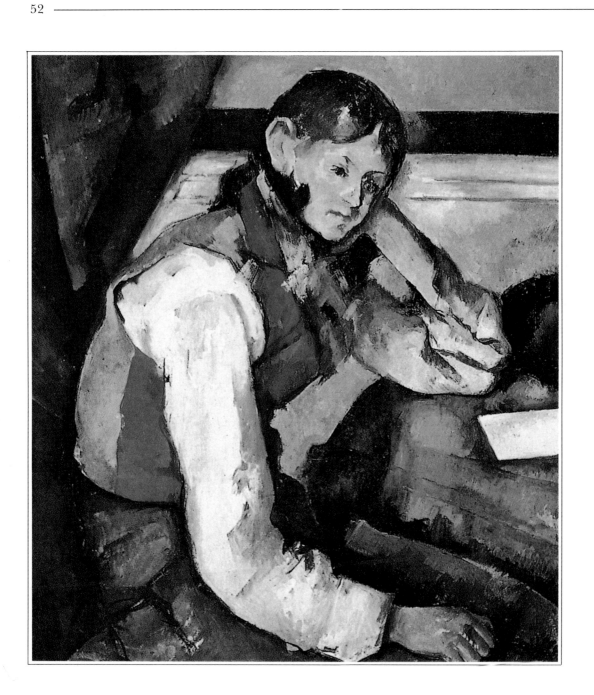

◁ **Boy in a Red Waistcoat** c.1890-5

Oil on canvas

CÉZANNE DID FOUR versions of *Boy in a Red Waistcoat,* the model for which is thought to have been an Italian called Michelangelo di Rosa. All four versions are examples of the artist's mature style and are painted in thin coats of colour. This version of the subject (now in Zurich) inspired one critic to remark on the length of the boy's arm, to which another, Max Lieberman, answered that the quality of its painting was so superb he wished the arm had gone on forever. Cézanne's main concern was not, of course, anatomical correctness but the overall formal completeness of his painting.

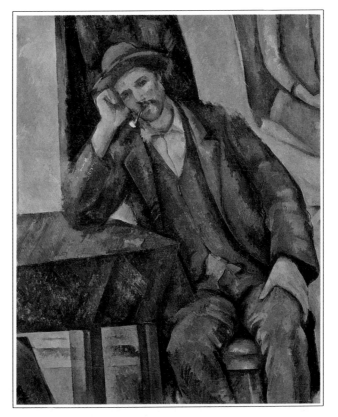

△ **Man with a Pipe, Leaning on a Table** 1895-1900

Oil on canvas

THE MAN SMOKING A PIPE, with his elbow on the table, was one of a group of friends who used to meet in a café, and who provided the inspiration and models for Cézanne's 'card players' paintings. This man clearly had to be persuaded to pose, to judge by his long-suffering expression. Cézanne's paintings may be divided into those which he painted from imagination in the studio and those which he painted from life, such as his portraits and still lifes, which all have a powerful sense of actuality.

▽ **Rocks, Forest of Fontainebleau** 1894-8

Oil on canvas

THE FOREST OF FONTAINEBLEAU has been popular with artists since the 1840s. Millet had moved there in 1849 to escape a cholera epidemic in Paris and had become the best-known of the painters who lived in and around the village of Barbizon. With Rousseau and others, Millet had created a school of painting which drew its subjects from the life of the countryside; gleaners, sowers, girls carrying milk cans, and other activities of country life featured in their work. Cézanne visited Fontainebleau briefly in 1894, during the period when he visited Monet at Giverny and disagreed with his aims. This sombre, powerful painting is, perhaps, Cezanne's summary in paint of the artists' disagreement.

▷ **Landscape; Ile de France** c.1895

Oil on canvas

THIS LANDSCAPE in the Ile de France in the vicinity of Paris shows Cézanne's total mastery of his personal style. The mostly vertical brushstrokes define the forms and distances by carefully graduated colour tones alone, moving from the warm greens of the foreground to the blue grey of the distant hills. The composition is closely knit with oval shapes of the grass in the park and the trees contrasted with the rectangular shapes of the houses and hills in the background.

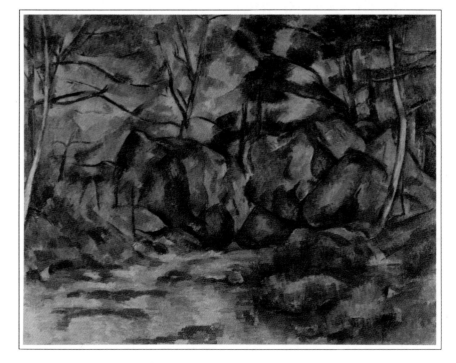

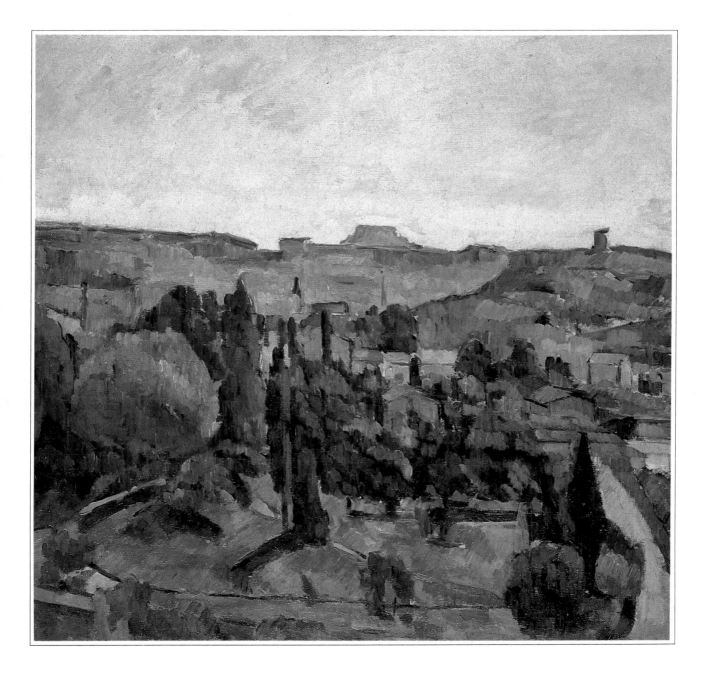

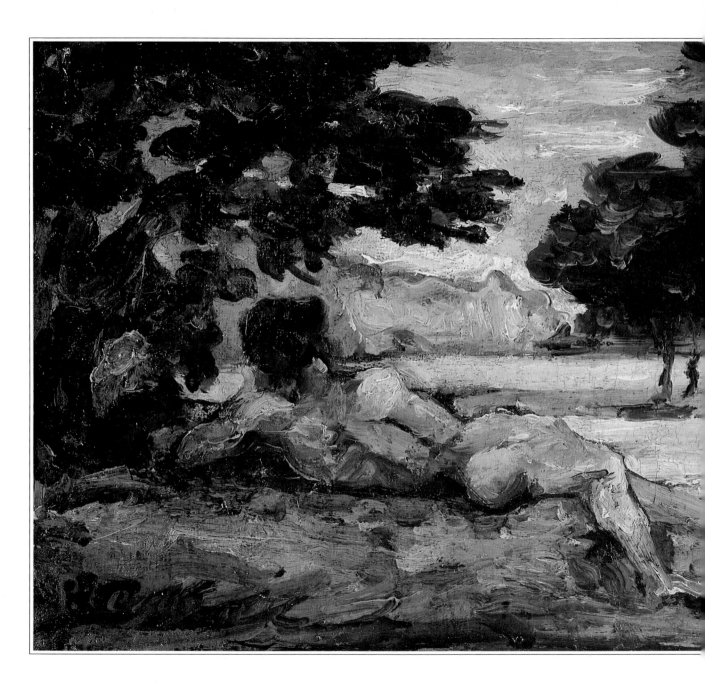

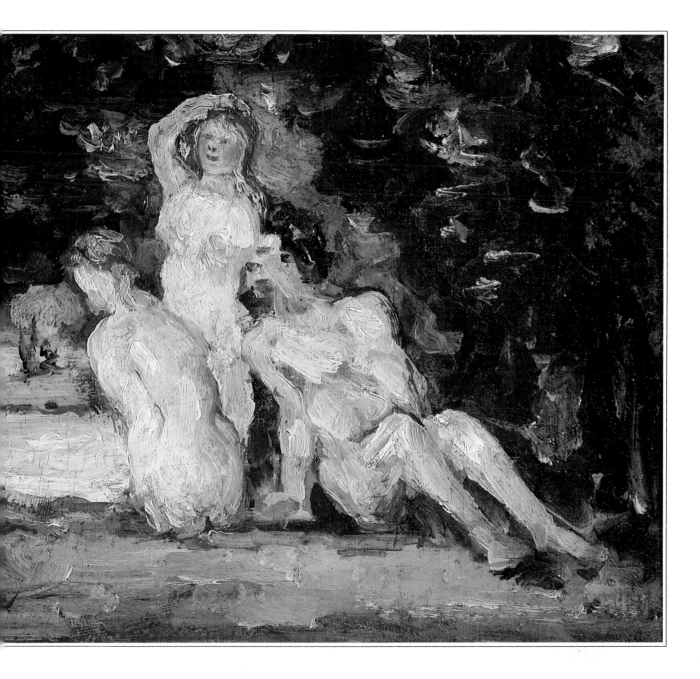

Bathers c.1894-95

Oil on canvas

◁ *Previous pages 56-57*

IN HIS CONTINUING OBSESSION
to paint a great masterpiece
with nude figures, Cézanne
made many studies, including
this one which falls somewhere
between the early, rather
baroque nude groups, with
erotic undertones, for which
he had even sketched a copy of
a Rubens nude, and the
uniquely 'Cézanne' approach
of his *Large Bathers* paintings.
It was as if Cézanne,
tormented when young by
erotic desires but afraid of
women, subdued his natural
feelings by a process of
sublimation, converting flesh
into an abstract arrangement
of colour planes.

▷ **Dish of Peaches** 1896

Oil on canvas

ALL THE POTS in this still life –
glazed earthenware, a small
majolica pot, a jug and a plate
– had been used by Cézanne in
other still lifes (and most of
them are still to be seen today
by the visitor to his studio in
Aix). At this period, Cézanne
was tending to fill his canvases
with more and more items,
bringing them together in
powerful, well-knit
compositions. They have a
monumental quality about
them which imprints itself on
the viewer's mind just as
forcefully as the epic and
heroic canvases of traditional
academic painting.

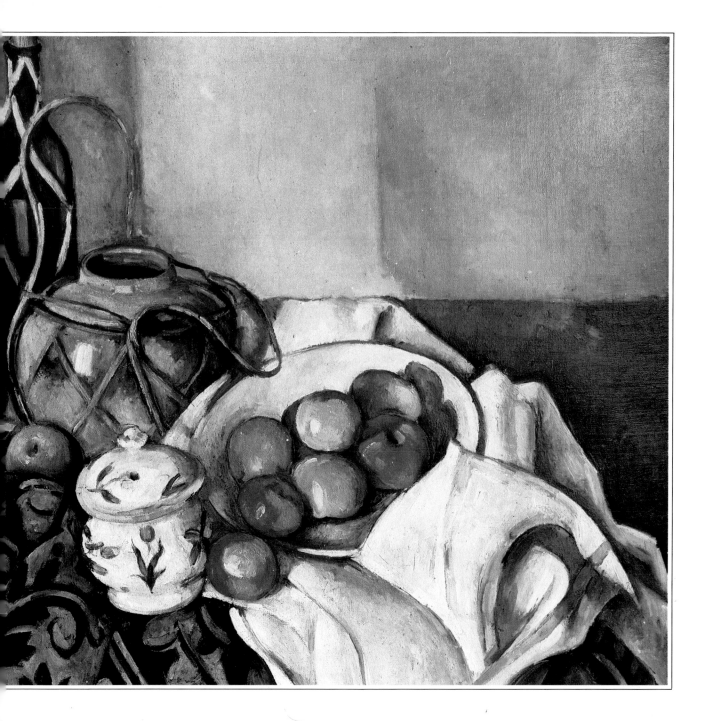

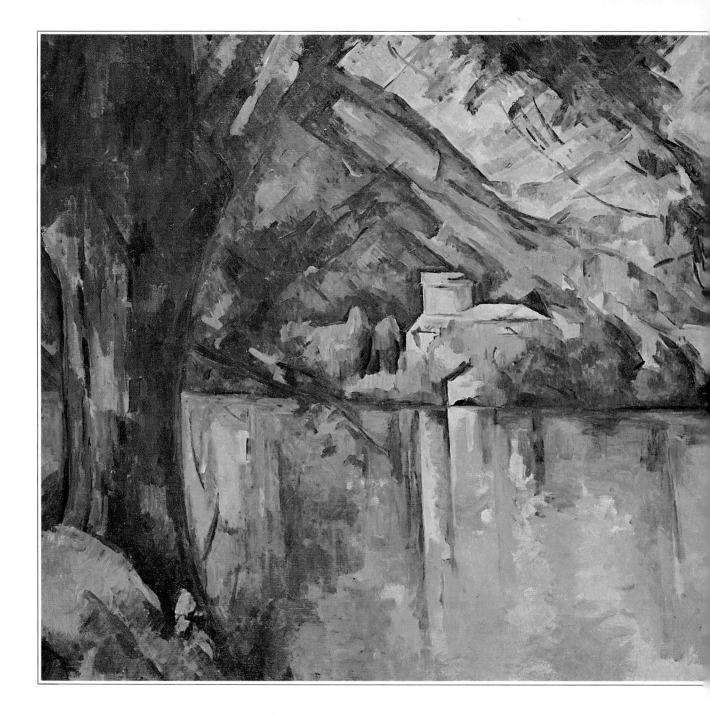

◁ **Lac d'Annecy** 1896

Oil on canvas

CÉZANNE VISITED Lake Annecy in France's Savoy Alps in 1896, after he had perfected his mature style. This painting shows that he was as much at home among the green mountains of the Alpine regions as among those of the drier Mediterranean. The Château de Duingt, the focal point of this picture, was painted by Cézanne from Talloires. Its solid presence is locked securely into the complex planes of mountain and overhanging foliage in the foreground, which sets the far shore in its proper perspective.

▷ **Still Life with Teapot** c.1898

Oil on canvas

THE VERY COLOURFUL tapestry behind this still life is unusual and becomes more than a part of the background, such as curtains did in several Cézanne still lifes. The little white teapot is a familiar object among the domestic bric-a-brac Cézanne included in many of his still lifes. In this painting its appearance in the arrangement is more than the artist's simple attachment to a pretty object: it has a formal value in the total composition. Cézanne's objects, wrote the critic Faire in 1926, 'acquire such a unity of character and force of expression that they come across as a law'.

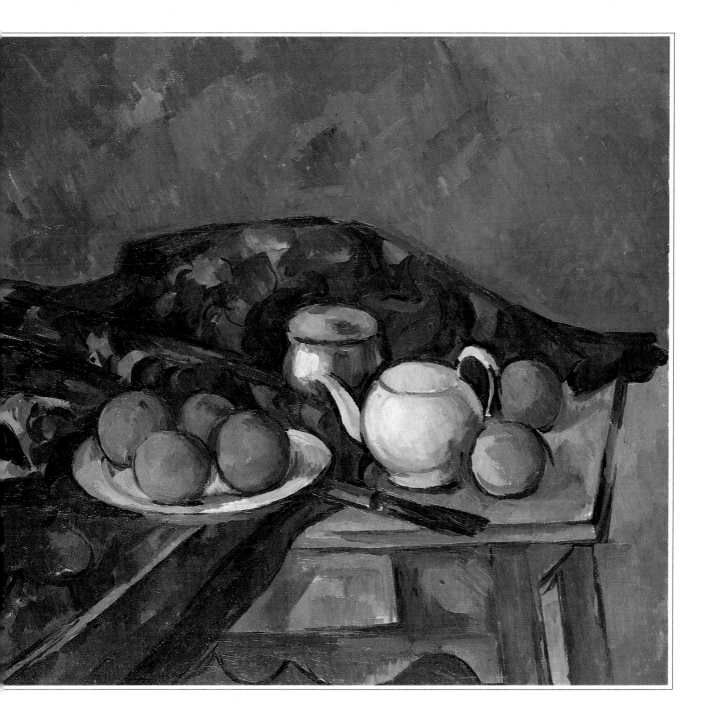

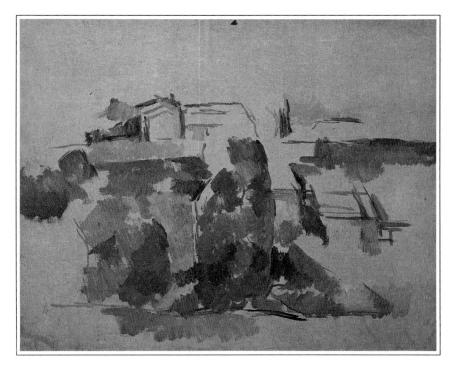

△ **House on a Hill close to Aix-en-Provence** c.1898

Watercolour

CÉZANNE REGARDED watercolour as supremely important in his art, eventually producing nearly 650 pictures in this very difficult medium; for many, he is one of the greatest masters of watercolour painting. His deliberate and painstaking technique is clearly illustrated in this unfinished watercolour. Unlike most painters, who lay in some indications of colour in faint washes and dots or lines to indicate the composition, Cézanne worked it all out in his head first. Having decided on the colour, tone and shape of his brushstroke, he then applied it firmly and without hesitation. The sum total of these applications of paint gives Cézanne's watercolours a powerful presence, the product of absolute conviction.

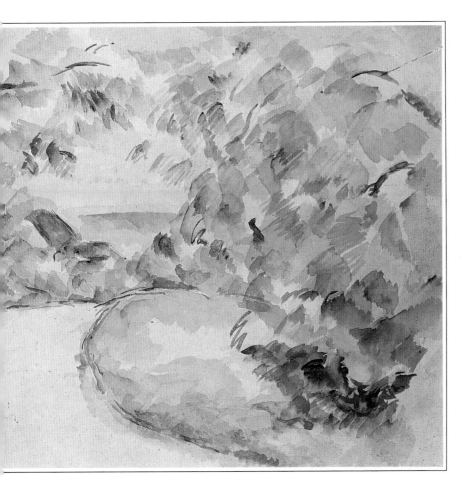

◁ **The Winding Road** c.1898

Watercolour

A BENDING ROAD was a motif which occurred frequently in Cézanne's paintings, most notably in the late 1870s and early 1880s, but also late in his life. In this lightly painted, late-period watercolour, Cézanne was seeking to convey the structure of a landscape almost without using material. To achieve this, he had to be convinced about the position, shape and direction of each brushstroke. The simplicity of the final image belies the intense thought behind it but still leaves a powerful impression, rather like the thread of single notes of a Schubert lieder.

▽ **Pyramid of Skulls** c.1900

Oil on canvas

CÉZANNE INCLUDED skulls in some of his early still lifes and returned to them in 1900, six years before his death. Perhaps death was in his mind, or perhaps he was preoccupied by his own feeling of having failed to reach his artistic goal and of the vanity of human endeavour. Little did he know then that he would come to be regarded as a genius who had re-established the eternal principles of painting after they had been lost to sight in the fashionable art world of the 19th century, or that he would be hailed as the originator of a new concept of art.

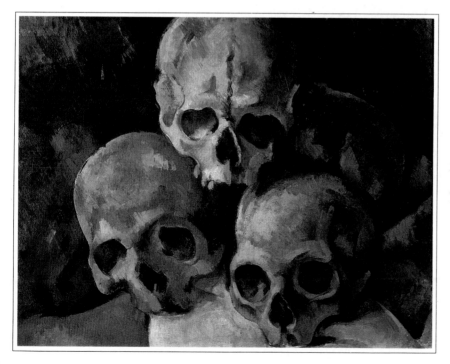

▷ **Flowers in a Blue Vase** c.1900

Oil on canvas

ALTHOUGH CÉZANNE set in motion a revolutionary approach to painting and has been hailed as the father of modern art, he was essentially a conservative person – he was not out to break with tradition, but eager to find a way to continue tradition in a way appropriate to his time. What he wanted was to follow in the steps of painters he admired, such as Poussin, with whom he had a great affinity, but to do so from nature. His insistence that each painter had to communicate with nature in order to find his personal answer to his art applied as much to still life as to landscape. These flowers in a blue vase were as much a part of nature as Mont Sainte-Victoire.

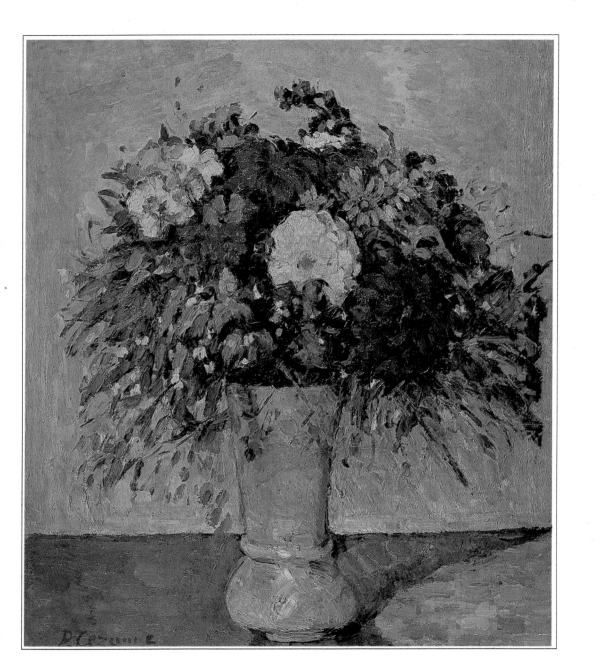

▷ **Still Life with Apples and Jug** c.1900

Oil on canvas

CÉZANNE'S GREATNESS was the greatness of all visionary painters: he could look at nature or an apple for hours and paint it for days and create a relationship with the landscape or fruit which was part the subject and part Cézanne. Writing to the painter Charles Camoin he explained that learning about painting was something that began with visits to the Louvre to see how others tackled the problems, but 'when you have made your rounds, hurry up and leave the great men to themselves. Get your second wind out there, in touch with nature, instincts and those inner impressions of art we all have.'

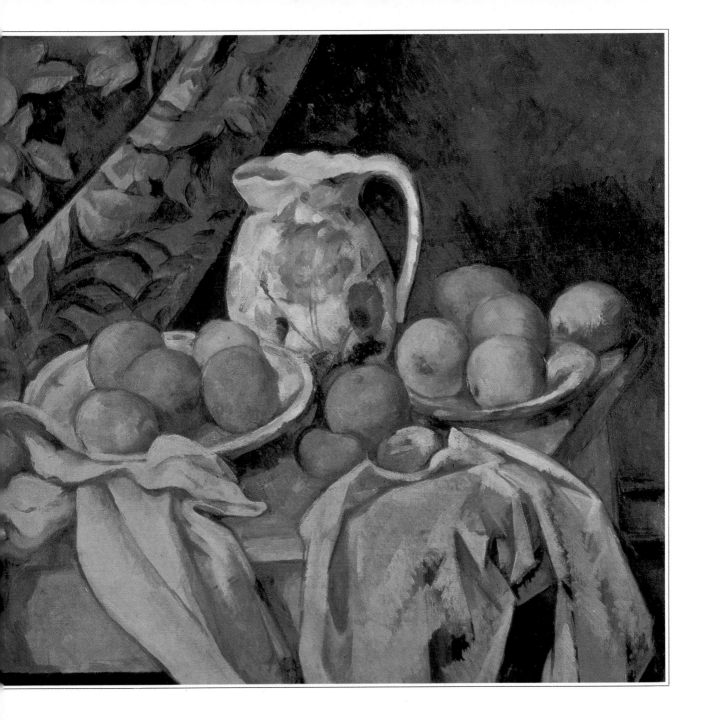

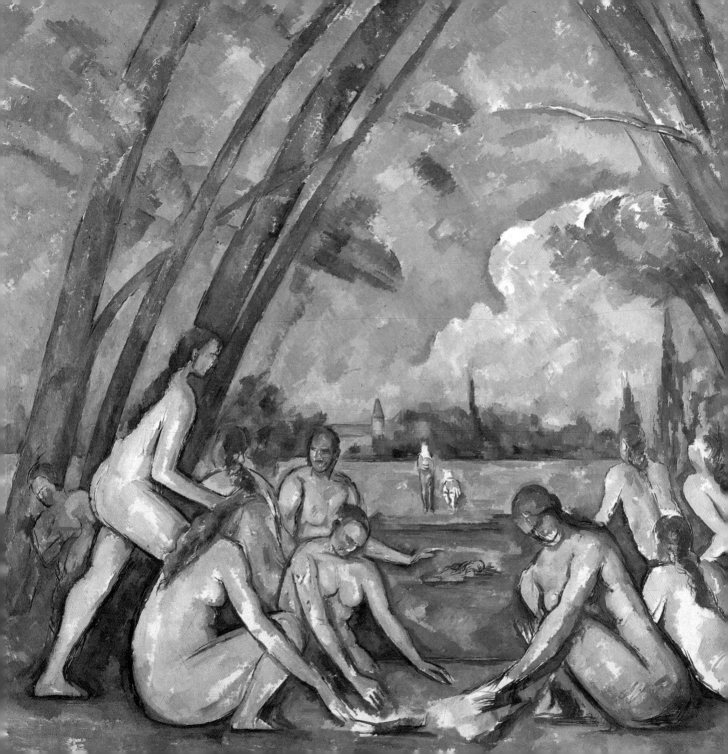

◁ **Group of Women (Les Grandes Baigneuses I)** 1898-1905

Oil on canvas

MEN AND WOMEN bathing in a landscape was a subject that obsessed Cézanne from the 1870s, and it was also one where he felt he had not found an answer. In his earlier efforts he painted many group figure studies, but the figures remained like actors on a stage, whereas what Cézanne wanted was to integrate figures and landscape into one great natural whole. In this picture, on which he worked for seven years, he changed natural proportions to fit the needs of the composition and welded the simplified planes of the bodies into the picture space. For many critics, it is the most perfectly concluded of the 'bathers' series, a masterpiece of artistic harmony between the figures and the landscape.

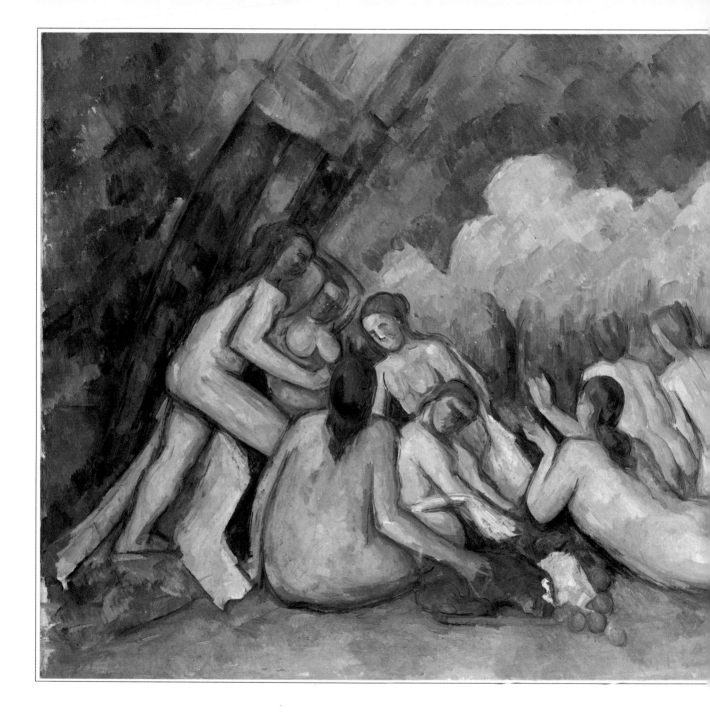

◁ **Group of Women
(Les Grandes Baigneuses II)**
1900-5

Oil on canvas

IN THE PAINTINGS of his
'bathers' series, Cézanne was
interested in the structural
relationship between groups of
bodies and their integration
with the landscape. In this
painting Cézanne has
arranged the women's figures
in such a way that they make a
formal composition in the two-
dimensional plane of the
canvas, but also have a spatial
relationship in depth. The
prone figure in the centre of
the picture, for example, plays
a significant role in focusing
the pictorial perspective:
figures and landscape have
become perfectly related in
this brilliant work.

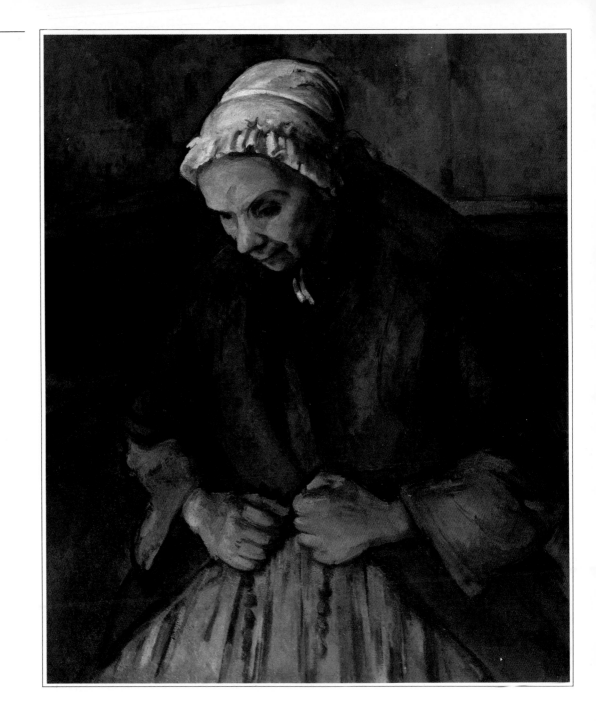

◁ **Old Woman with a Rosary** 1900-4

Oil on canvas

THOUGH CÉZANNE tends to avoid the emotional content of his sitters, he has not been able to do so in this moving painting. He himself was over 60 when he painted her, and perhaps he felt a certain empathy for an old peasant woman worn out with toil and with few compensations for her life but her enduring faith. Perhaps unconsciously, Cézanne thought of his own steadfast belief in his vision of his art and its lack of success. As with his last painting of old Vallier the gardener, there is no doubt that these last paintings possess an extra depth of feeling.

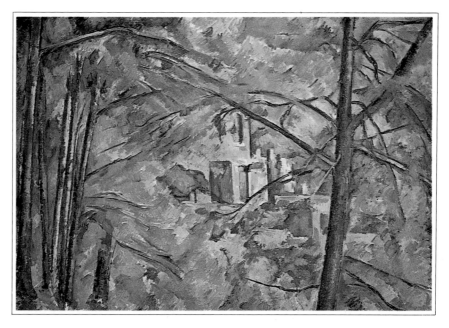

△ **Château Noir** c.1904

Oil on canvas

CHATEAU NOIR, near Aix-en-Provence, attracted Cézanne's attention in his last years. It was a place with fine woods, and the park contained a mill and water tank which appear in some of Cézanne's paintings of the area. The château itself stood on an outcrop of rock, dominating the countryside about it. With Bibémus, nearby, this was the countryside which Cézanne loved best and on which he lavished his last efforts to create an art as light as thought and strong as truth.

▷ **The Gardener** c.1906

Oil on canvas

THE GARDENER, like Madame Cézanne in the conservatory, has a restful, static air about him – no doubt induced in the sitter by the long hours that the painter expected him to sit still. His name was Vallier and he was gardener and odd-job man at Cézanne's house at Aix. He sat for six paintings, including this one which was completed just before Cézanne's death in October, 1906. The painting is done with very light layers of paint loosely applied but giving a great feeling of strength and structure as, for example, in the painting of the legs, in which the perspective is suggested in very few strokes of the brush. This and other late paintings of Cézanne are seen by critics as direct forerunners of cubism.

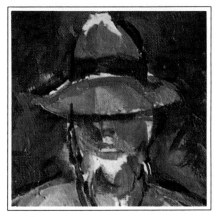

Detail

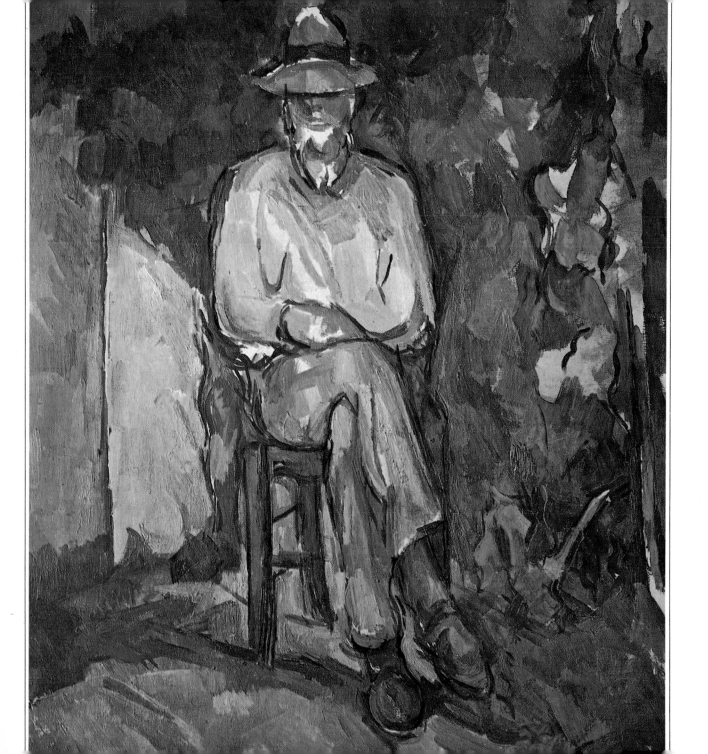

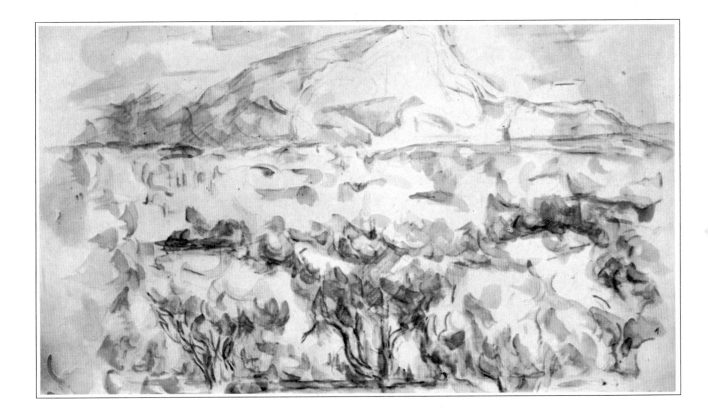

△ **Mont Sainte-Victoire** c.1906

Watercolour

IT WAS FITTING that at the end of his life Cézanne should have returned to Mont Sainte-Victoire to define his favourite landscape subject with the powerful simplicity of expression which he had finally arrived at in his art. Watercolour suited his new approach to his subject, for it was less obtrusive than oil, yet it could carry the message and express the thought just as powerfully. It was as if Cézanne had found a way of transmitting pictorial thought almost without the need of a medium.

ACKNOWLEDGEMENTS

The Publisher would like to thank the following for their kind permission to reproduce the paintings in this book:

Reproduced by courtesy of the Trustees, National Gallery, London 40-41, 72-73, 74; **Philadelphia Museum of Art : Purchased : W. P Wilstach Collection** 70-71; **National Museum of Wales, Cardiff** 62-63.

Bridgeman Art Library, London /Christie's London 12, 14, 37, 47, 55, 56-57, 64, 65; /**Courtauld Institue Galleries, University of London** 48, 49, 50-51, 60-61; /**Giraudon/Museu de Arte, São Paulo** 45; /**Giraudon/Musée d'Orsay** 8, 18-19, 24-25, 26-27, 38-39; /**Grand Palais Exhibition, Paris** 66; /**Hermitage, St. Petersburg** 13, 67, 68-69; /**Louvre, Paris** 16-17, 22-23, 46; /**Metropolitan Museum of Art, New York** 32-33; /**Minneapolis Society of Fine Arts, Minnesota** 28-29; /**Musée d'Orsay, Paris** 15; /**National Museum of Wales, Cardiff** 20-21; /**Private Collection** 10, 11, 24, 58-59, 75; /**Pushkin Museum, Moscow** 30-31, 34-35, 36, 42, 43, 53; /**Sammlung Bührle, Zurich** 44, 52; /**Tate Gallery, London** 76, 77, 78; /**Walker Art Gallery, Liverpool** 9; **Kunsthaus Zürich** 54.